ANNE GEDDES

Down in the Garden

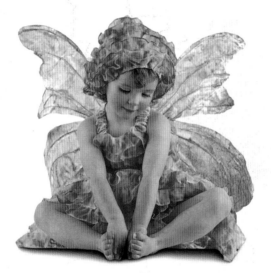

BIRTHDAYS

Cedco Publishing Company

ANNE GEDDES ™

ISBN-1-55912-019-3

© 1996 Anne Geddes

Published in 1996 by Cedco Publishing Company
2955 Kerner Blvd., San Rafael, CA 94901

Fourth Printing, April 1997

Designed by Jane Seabrook
Produced by Kel Geddes
Typeset by Image Design
Images first published in *Down in the Garden*.
Color separations by Image Centre
Printed by South China Printing Co. Ltd., Hong Kong

Anne Geddes is a registered trademark of The Especially Kids Company Limited.

Please write to us for a FREE FULL COLOR catalog of our fine Anne Geddes calendars
and books, Cedco Publishing Company, 2955 Kerner Blvd., San Rafael, CA 94901.

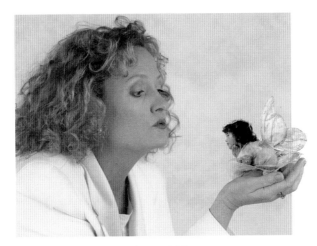

Anne and Lilly

"*I am frequently asked why I photograph babies so often, and where my ideas come from. Little babies are indeed my inspiration, and I can not imagine a photographic life without them playing a major part in it. Where this special love for babies comes from I can not tell you, and I have spent much time searching for an answer myself. All I know is that they are perfect little human beings in their own way, and we should all take time to cherish them, especially while they are very small.*" Anne Geddes

These words are taken from the foreword to Anne's latest book, *Down in the Garden*. They give an insight to the special magic that Anne is able to create in her photographic works.

A visit to Anne's garden and her unique vision of all that is beautiful is a journey that shouldn't be missed.

JANUARY

Name _____ *Date* _____

Gifts _____

Name _____ *Date* _____

Gifts _____

Name _____ *Date* _____

Gifts _____

Name _____ *Date* _____

Gifts _____

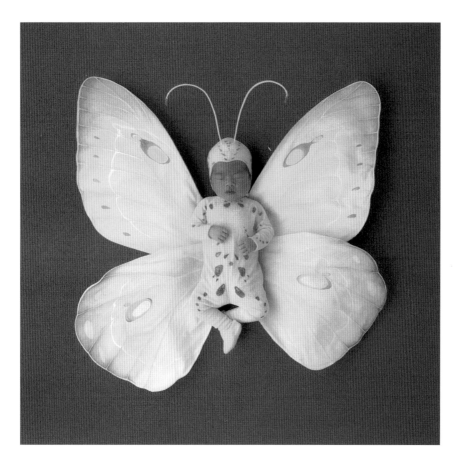

JANUARY

Name _____ Date _____

Gifts _____

Name _____ Date _____

Gifts _____

Name _____ Date _____

Gifts _____

Name _____ Date _____

Gifts _____

Name _____ Date _____

Gifts _____

JANUARY

Name _____ *Date* _____

Gifts _____

Name _____ *Date* _____

Gifts _____

Name _____ *Date* _____

Gifts _____

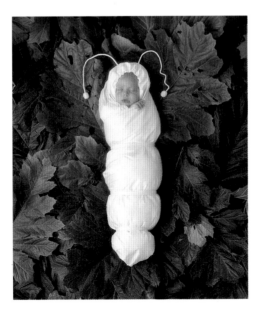

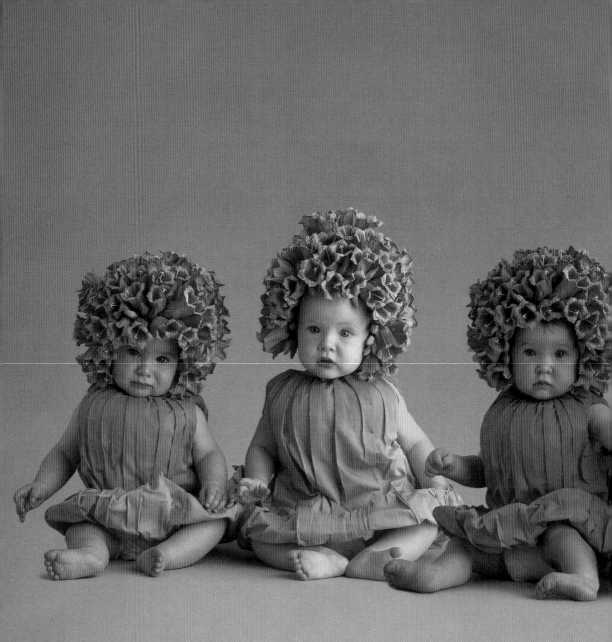

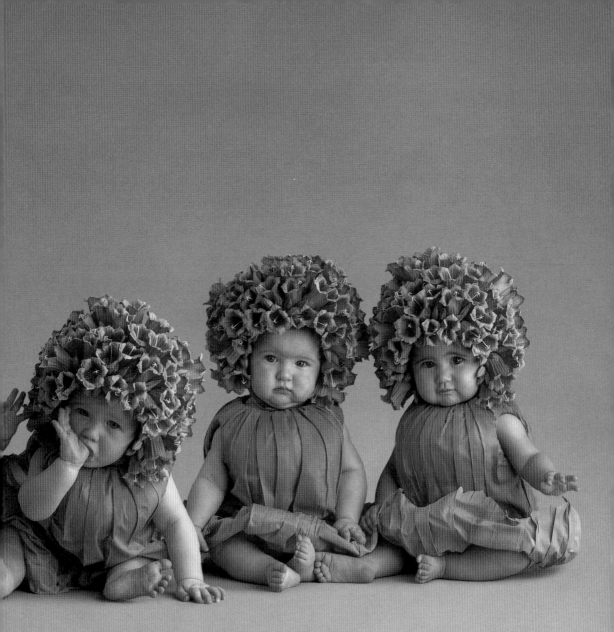

Canterbury Belles

JANUARY

Name _____ Date _____

Gifts _____

Name _____ Date _____

Gifts _____

Name _____ Date _____

Gifts _____

Name _____ Date _____

Gifts _____

Name _____ Date _____

Gifts _____

SPECIAL OCCASIONS

F E B R U A R Y

Name _____ Date _____

Gifts _____

Name _____ Date _____

Gifts _____

Name _____ Date _____

Gifts _____

Name _____ Date _____

Gifts _____

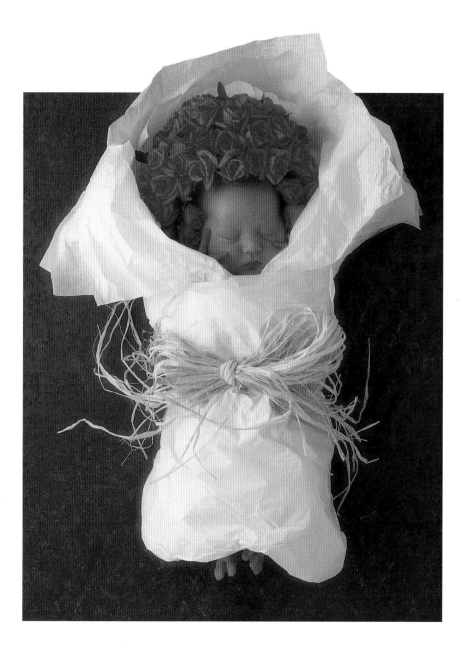

FEBRUARY

Name _____ Date _____

Gifts _____

Name _____ Date _____

Gifts _____

Name _____ Date _____

Gifts _____

Name _____ Date _____

Gifts _____

Name _____ Date _____

Gifts _____

FEBRUARY

Name _____ *Date* _____

Gifts _____

Name _____ *Date* _____

Gifts _____

Name _____ *Date* _____

Gifts _____

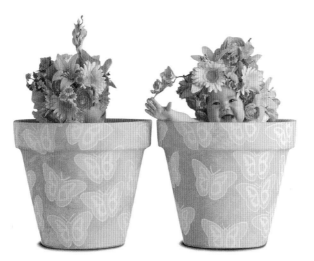

FEBRUARY

Name _____ Date _____

Gifts _____

Name _____ Date _____

Gifts _____

Name _____ Date _____

Gifts _____

Name _____ Date _____

Gifts _____

Name _____ Date _____

Gifts _____

SPECIAL OCCASIONS

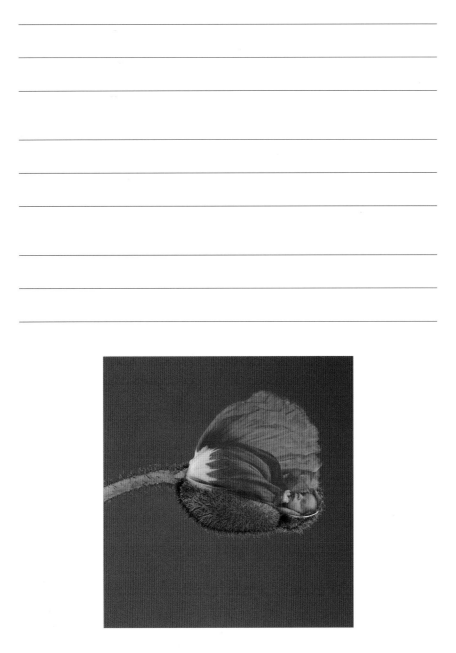

MARCH

Name

Gifts Date

Name Date

Gifts

Name Date

Gifts

Name Date

Gifts

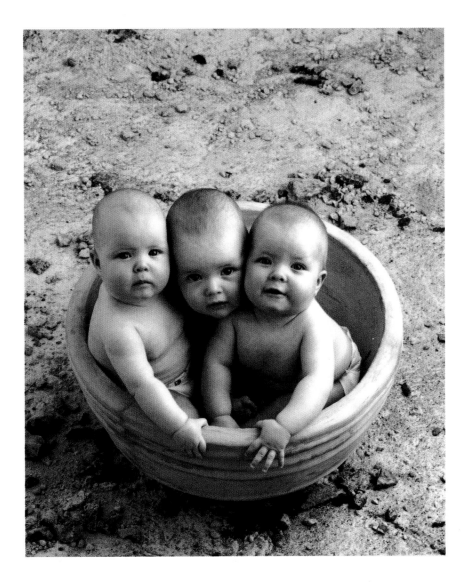

MARCH

Name _____ Date _____

Gifts _____

Name _____ Date _____

Gifts _____

Name _____

Date _____

Gifts _____

Name _____ Date _____

Gifts _____

Name _____ Date _____

Gifts _____

MARCH

Name _____ Date _____

Gifts _____

Name _____ Date _____

Gifts _____

Name _____ Date _____

Gifts _____

Name _____ Date _____

Gifts _____

Name _____ Date _____

Gifts _____

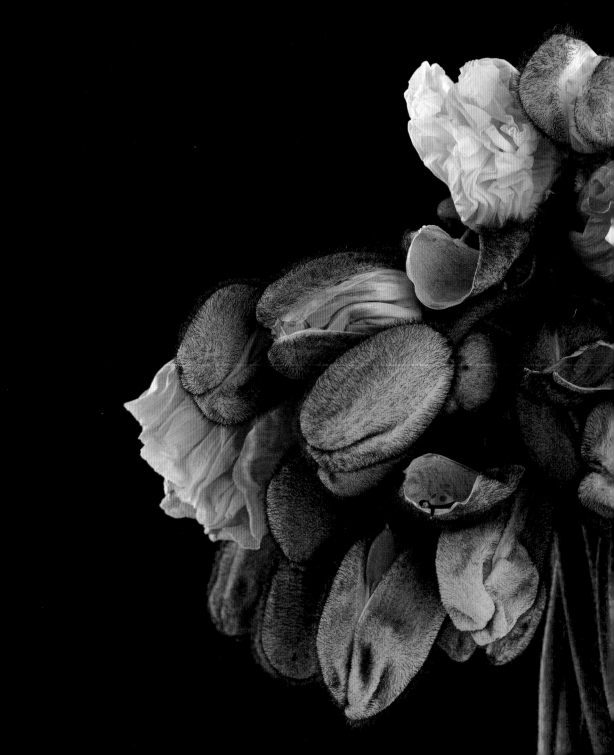

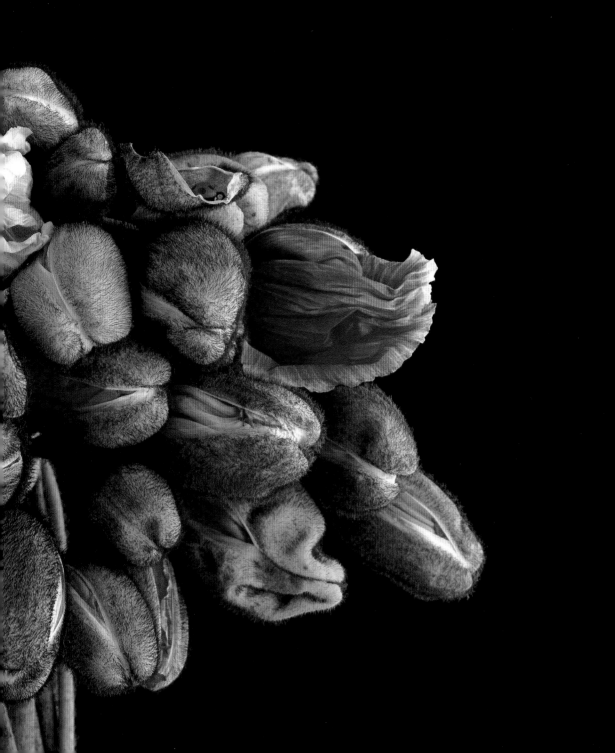

MARCH

Name _____ Date _____

Gifts _____

Name _____ Date _____

Gifts _____

Name _____ Date _____

Gifts _____

Name _____ Date _____

Gifts _____

Name _____ Date _____

Gifts _____

SPECIAL OCCASIONS

APRIL

Name _____ Date _____

Gifts _____

Name _____ Date _____

Gifts _____

Name _____ Date _____

Gifts _____

Name _____ Date _____

Gifts _____

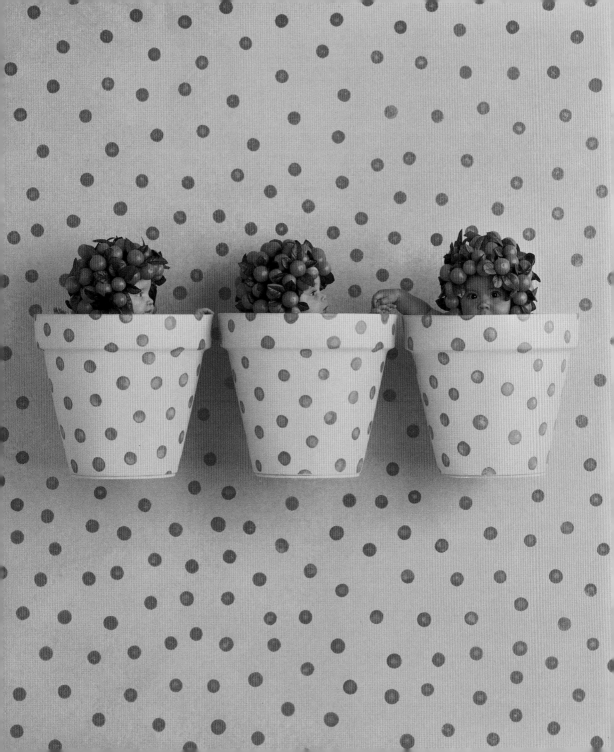

Aᴘʀɪʟ

Name _____ Date _____

Gifts _____

Name _____ Date _____

Gifts _____

Name _____ Date _____

Gifts _____

Name _____ Date _____

Gifts _____

Name _____ Date _____

Gifts _____

APRIL

Name

Date

Gifts

Name

Date

Gifts

Name

Date

Gifts

Name

Date

Gifts

Name

Date

Gifts

APRIL

Name _____ *Date* _____

Gifts _____

Name _____ *Date* _____

Gifts _____

Name _____ *Date* _____

Gifts _____

Name _____ *Date* _____

Gifts _____

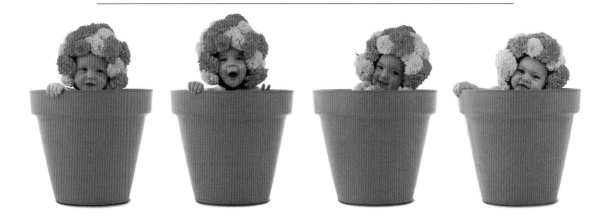

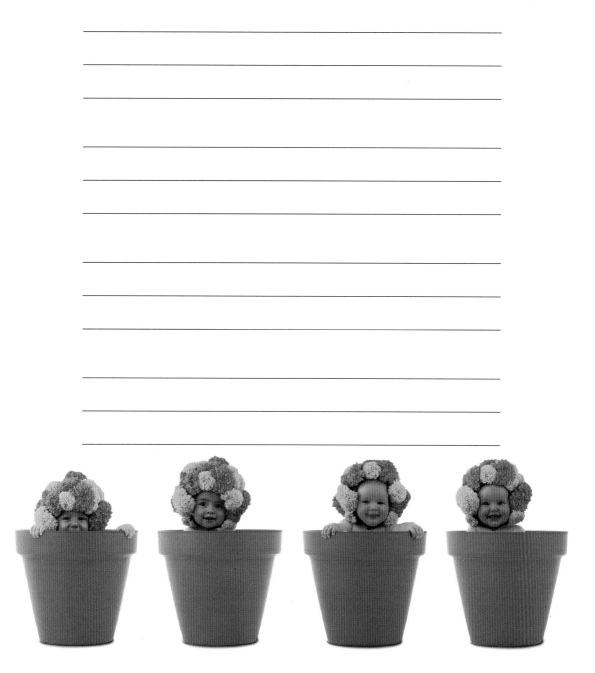

MAY

Name _____ Date _____

Gifts _____

Name _____ Date _____

Gifts _____

Name _____ Date _____

Gifts _____

Name _____ Date _____

Gifts _____

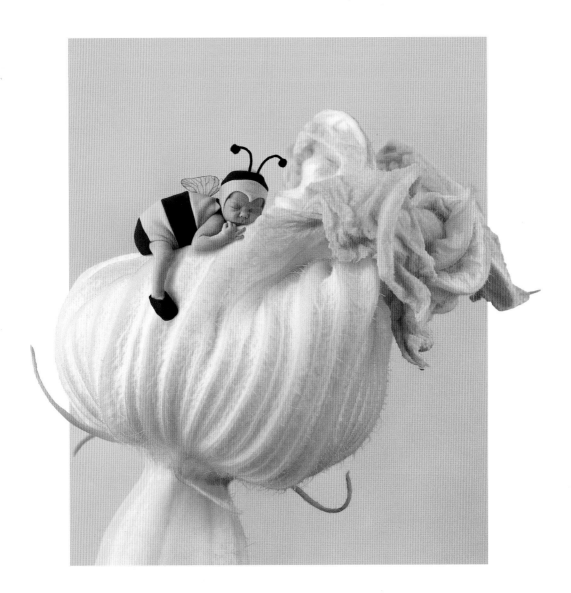

MAY

Name _____ Date _____

Gifts _____

Name _____ Date _____

Gifts _____

Name _____ Date _____

Gifts _____

Name _____ Date _____

Gifts _____

Name _____ Date _____

Gifts _____

MAY

Name _____ Date _____

Gifts _____

Name _____ Date _____

Gifts _____

Name _____ Date _____

Gifts _____

Name _____ Date _____

Gifts _____

Name _____ Date _____

Gifts _____

M A Y

Name

Gifts Date

Name Date

Gifts

Name Date

Gifts

Name Date

Gifts

Name Date

Gifts

SPECIAL OCCASIONS

JUNE

Name _____ Date _____

Gifts _____

Name _____ Date _____

Gifts _____

Name _____ Date _____

Gifts _____

Name _____ Date _____

Gifts _____

JUNE

Name _____ Date _____

Gifts _____

Name _____ Date _____

Gifts _____

Name _____ Date _____

Gifts _____

Name _____ Date _____

Gifts _____

Name _____ Date _____

Gifts _____

JUNE

Name _____ Date _____

Gifts _____

Name _____ Date _____

Gifts _____

Name _____ Date _____

Gifts _____

JUNE

Name _____ Date _____

Gifts _____

Name _____ Date _____

Gifts _____

Name _____ Date _____

Gifts _____

Name _____ Date _____

Gifts _____

Name _____ Date _____

Gifts _____

JULY

Name _____ Date _____

Gifts _____

Name _____ Date _____

Gifts _____

Name _____ Date _____

Gifts _____

Name _____ Date _____

Gifts _____

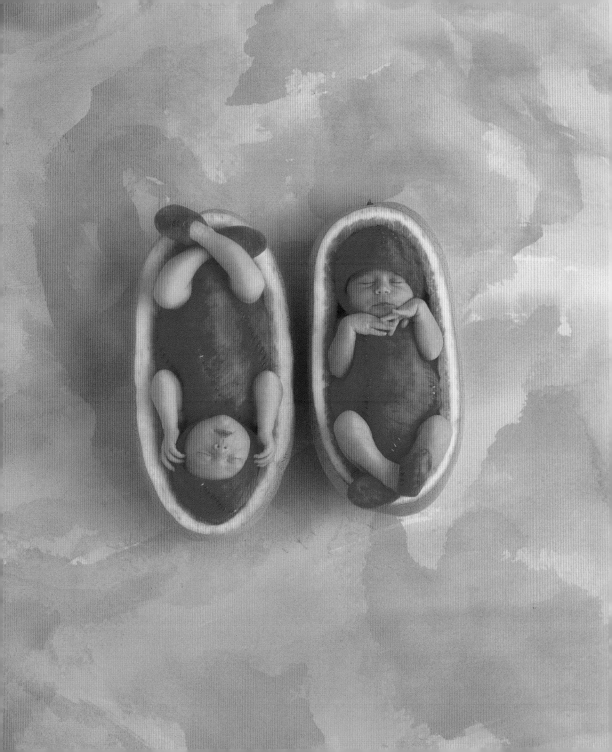

July

Name _____ Date _____

Gifts _____

Name _____ Date _____

Gifts _____

Name _____ Date _____

Gifts _____

Name _____ Date _____

Gifts _____

Name _____ Date _____

Gifts _____

JULY

Name _____ Date _____

Gifts _____

Name _____ Date _____

Gifts _____

Name _____ Date _____

Gifts _____

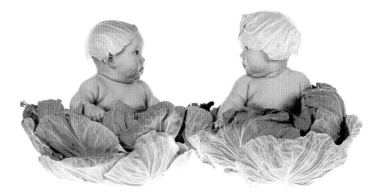

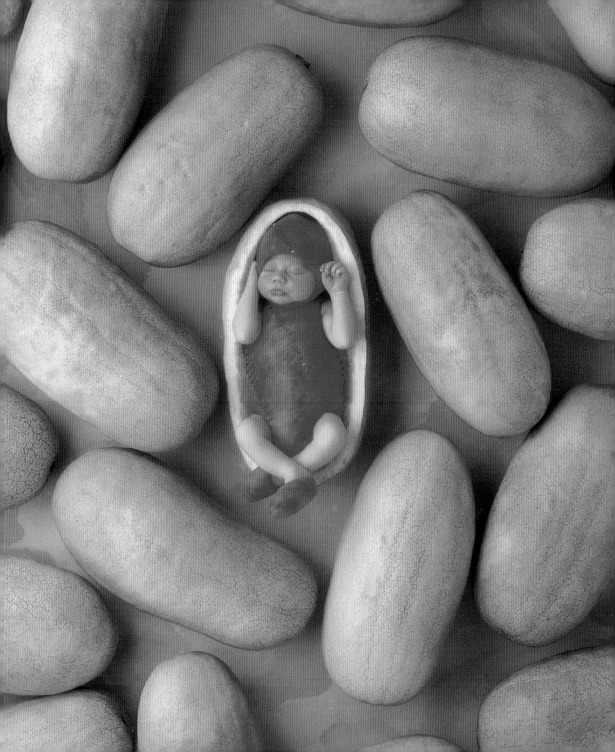

J U L Y

Name *Date*

Gifts

Name *Date*

Gifts

Name *Date*

Gifts

Name *Date*

Gifts

Name *Date*

Gifts

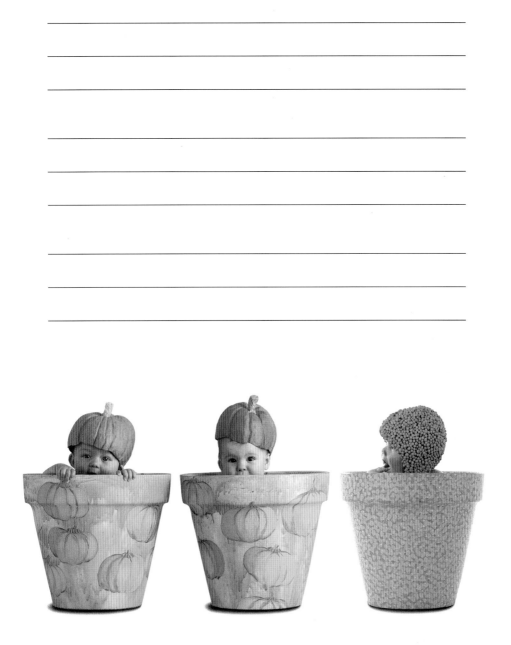

AUGUST

Name _____ Date _____

Gifts _____

Name _____ Date _____

Gifts _____

Name _____ Date _____

Gifts _____

Name _____ Date _____

Gifts _____

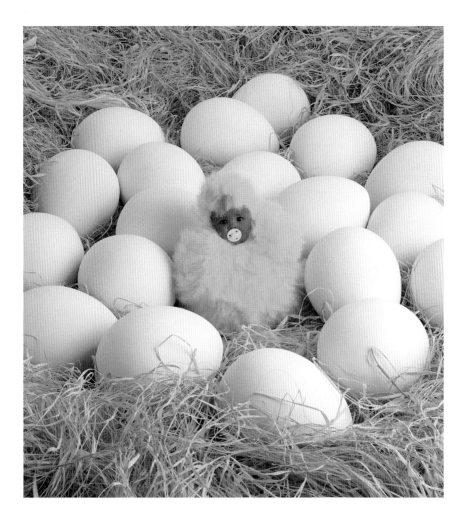

AUGUST

Name _____ Date _____

Gifts _____

Name _____ Date _____

Gifts _____

Name _____ Date _____

Gifts _____

Name _____ Date _____

Gifts _____

Name _____ Date _____

Gifts _____

AUGUST

Name _____ Date _____

Gifts _____

Name _____ Date _____

Gifts _____

Name _____

Date _____

Gifts _____

Name _____

Date _____

Gifts _____

Name _____

Date _____

Gifts _____

Aᴜɢᴜsᴛ

Name _____ Date _____

Gifts _____

Name _____ Date _____

Gifts _____

Name _____ Date _____

Gifts _____

Name _____ Date _____

Gifts _____

Name _____ Date _____

Gifts _____

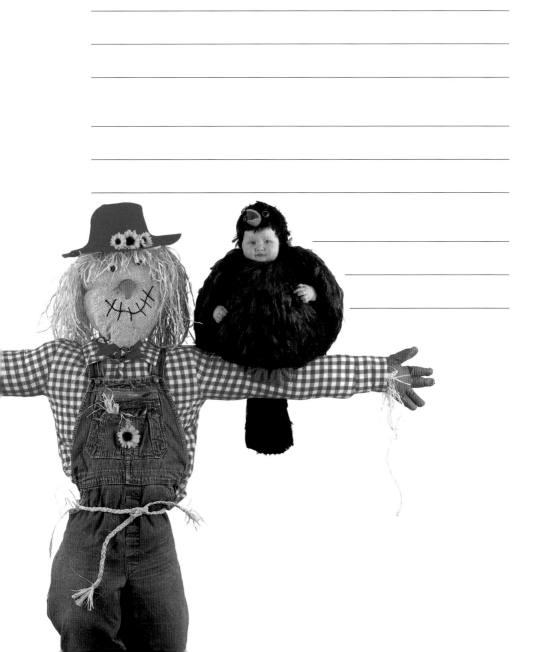

September

Name _____ Date _____

Gifts _____

Name _____ Date _____

Gifts _____

Name _____ Date _____

Gifts _____

Name _____ Date _____

Gifts _____

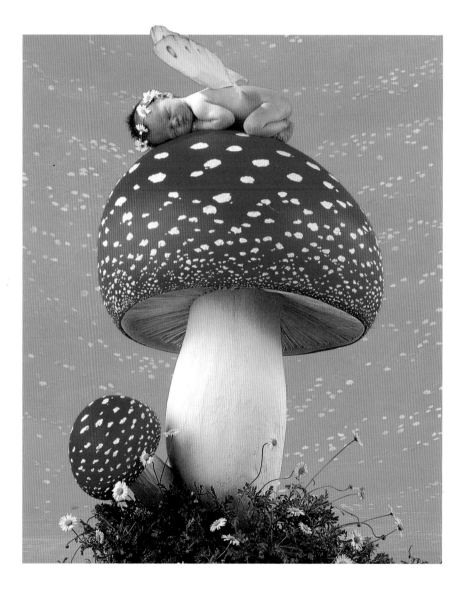

SEPTEMBER

Name _____

Date _____

Gifts _____

Name _____

Date _____

Gifts _____

Name _____ Date _____

Gifts _____

Name _____ Date _____

Gifts _____

Name _____ Date _____

Gifts _____

SEPTEMBER

Name _____ Date _____

Gifts _____

Name _____ Date _____

Gifts _____

Name _____ Date _____

Gifts _____

Name _____

Date _____

Gifts _____

Name _____

Date _____

Gifts _____

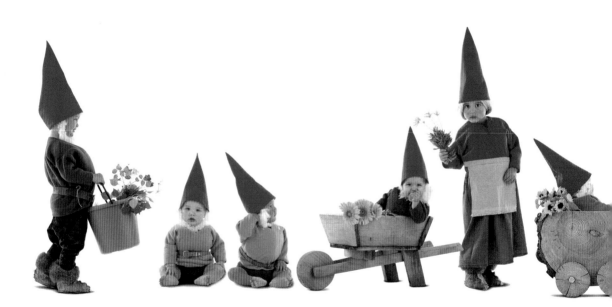

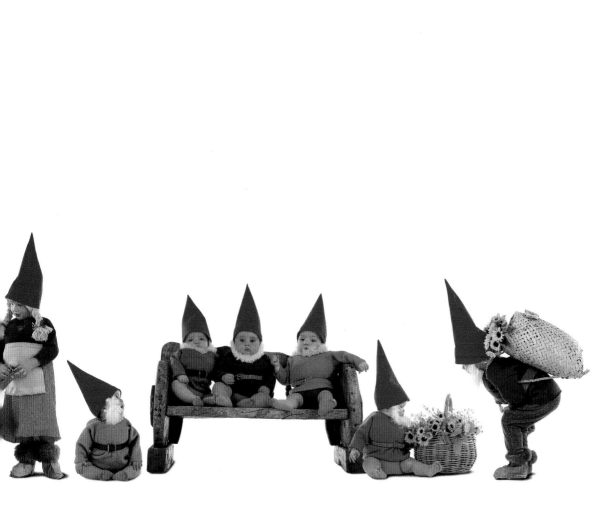

S EPTEMBER

Name _____ Date _____

Gifts _____

Name _____ Date _____

Gifts _____

Name _____ Date _____

Gifts _____

Name _____ Date _____

Gifts _____

Name _____ Date _____

Gifts _____

SPECIAL OCCASIONS

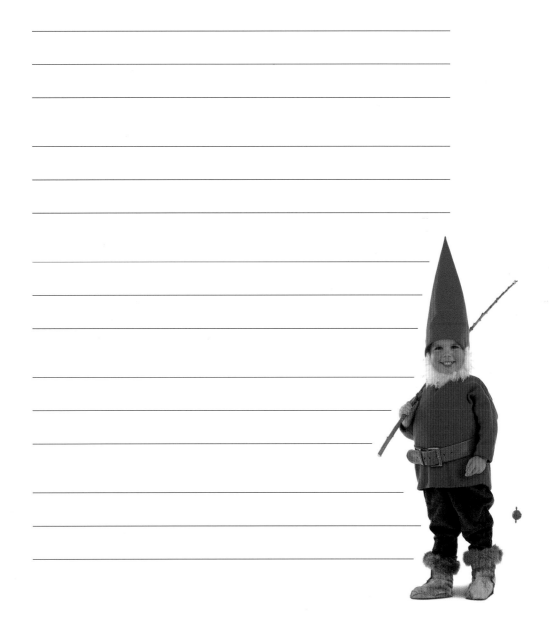

OCTOBER

Name _____ Date _____

Gifts _____

Name _____ Date _____

Gifts _____

Name _____ Date _____

Gifts _____

Name _____ Date _____

Gifts _____

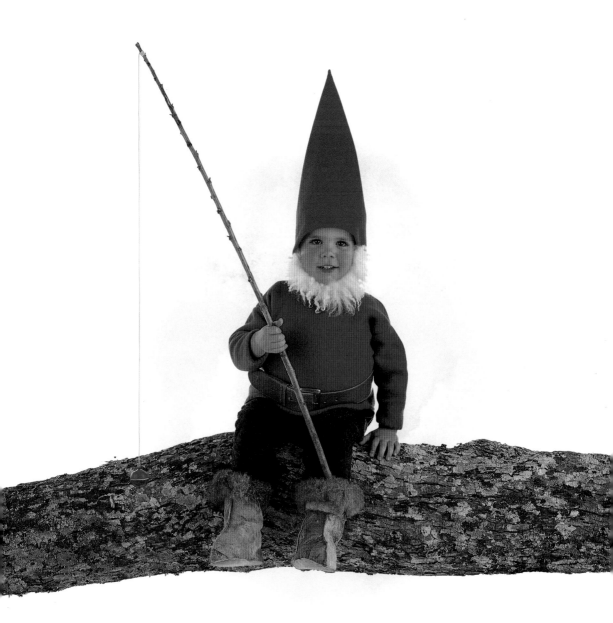

O CTOBER

Name _____ Date _____

Gifts _____

Name _____ Date _____

Gifts _____

Name _____

Date _____

Gifts _____

Name _____

Date _____

Gifts _____

Name _____ Date _____

Gifts _____

OCTOBER

Name _____ Date _____

Gifts _____

Name _____ Date _____

Gifts _____

Name _____ Date _____

Gifts _____

Name _____ Date _____

Gifts _____

Name _____ Date _____

Gifts _____

OCTOBER

Name _____ *Date* _____

Gifts _____

Name _____ *Date* _____

Gifts _____

Name _____ *Date* _____

Gifts _____

Name _____ *Date* _____

Gifts _____

Name _____ *Date* _____

Gifts _____

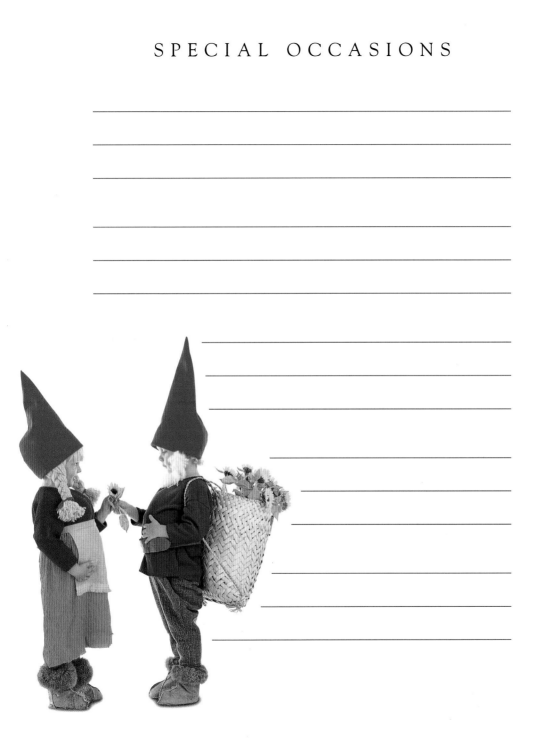

November

Name _____ Date _____

Gifts _____

Name _____ Date _____

Gifts _____

Name _____ Date _____

Gifts _____

Name _____ Date _____

Gifts _____

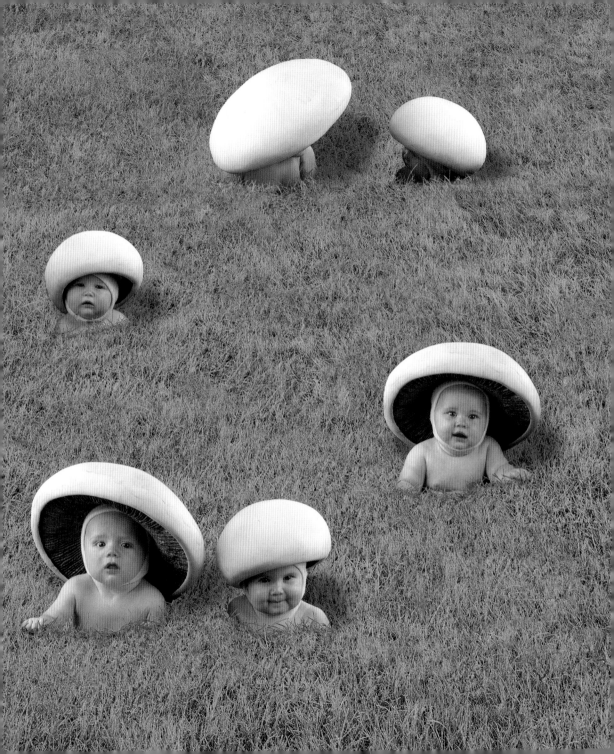

NOVEMBER

Name _____ Date _____

Gifts _____

Name _____ Date _____

Gifts _____

Name _____ Date _____

Gifts _____

Name _____ Date _____

Gifts _____

Name _____ Date _____

Gifts _____

November

Name _____ Date _____

Gifts _____

Name _____

Date _____

Gifts _____

Name _____ Date _____

Gifts _____

Name _____ Date _____

Gifts _____

Name _____ Date _____

Gifts _____

November

Name *Date*

Gifts

Name *Date*

Gifts

Name *Date*

Gifts

Name *Date*

Gifts

Name *Date*

Gifts

SPECIAL OCCASIONS

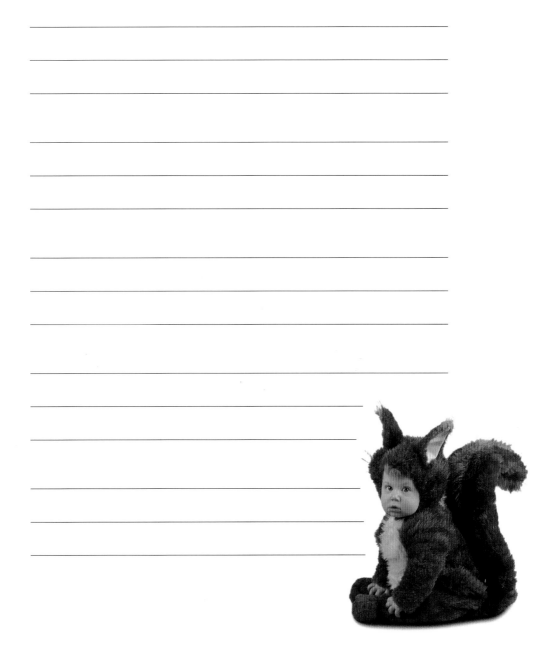

DECEMBER

Name _____ *Date* _____

Gifts _____

Name _____ *Date* _____

Gifts _____

Name _____ *Date* _____

Gifts _____

Name _____ *Date* _____

Gifts _____

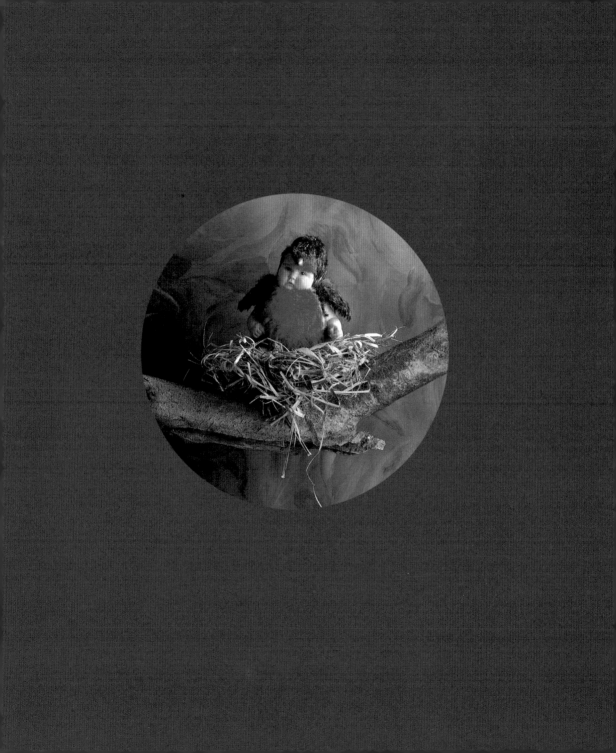

DECEMBER

Name _____ Date _____

Gifts _____

Name _____ Date _____

Gifts _____

Name _____ Date _____

Gifts _____

Name _____ Date _____

Gifts _____

Name _____ Date _____

Gifts _____

DECEMBER

Name _____ Date _____

Gifts _____

Name _____

Date _____

Gifts _____

Name _____

Date _____

Gifts _____

Name _____

Date _____

Gifts _____

Name _____

Date _____

Gifts _____

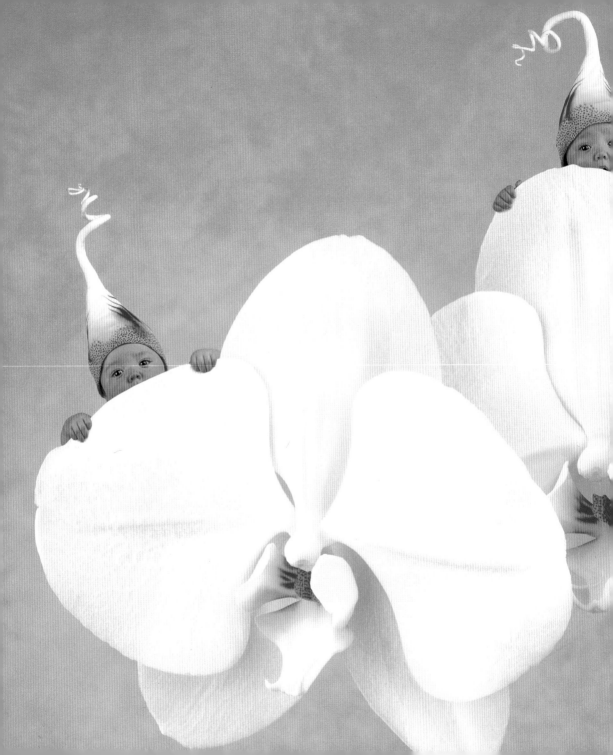

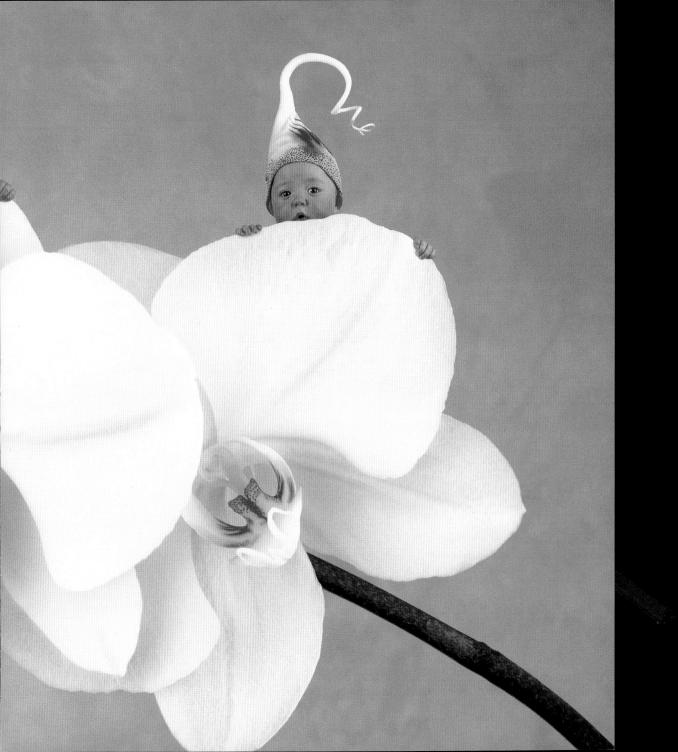

DECEMBER

Name _____ *Date* _____

Gifts _____

Name _____

Date _____

Gifts _____

Name _____

Date _____

Gifts _____

Name _____ *Date* _____

Gifts _____

Name _____ *Date* _____

Gifts _____

SPECIAL OCCASIONS

STAR SIGNS

AQUARIUS *21 January – 19 February*

Eccentric, uncompromising, unconventional and unpredictable, Aquarians hate pretense. They are great intellectual snobs, but they're definitely not social ones and instead are often committed humanitarians with strong social and political consciences. In fact their love for man as a whole often overrides their love of individuals, and they are hard to get to know intimately and find difficulty forming long-term relationships. They love to argue, and will come up with innovative ideas, but they fall short in applying them. They are natural performers. In their desire for freedom, they tend to shun the constraints of conventional marriages.

Perfect partner: Scorpio.

Disasters: Cancer.

PISCES *20 February – 20 March*

The original chameleons, elusive Pisceans constantly change their feelings and ideas and will see something of value in everything – even opposites. They are very intuitive, sensitive and idealistic, but often lack common sense. They hate confrontations, and have the knack of seeming compliant while continuing to do exactly as they please. They can become visionaries or mystics, but at their worst may embrace the escapism offered by drugs or alcohol. They are great romantics, known for their desire to see everything through rose-colored glasses, but in their search for an ideal soul mate they are frequently drawn to domineering types.

Perfect partners: Capricorn, Taurus.

Disasters: Gemini.

STAR SIGNS

ARIES *21 March – 20 April*

Optimistic, assertive and lively, Arians throw themselves headlong at life. They know what they want, and they want it immediately and will pursue their ambitions relentlessly. They hate delays, and can be impatient and intolerant. They have strong egos and need new challenges and constant flattery to be really happy. They hate to take advice and can be bossy, but will never bear grudges. Their generous and bawdy natures make them fun companions, but if they feel excitement is lacking, you can rely on them to generate a few crises to liven things up!

Perfect partner: Gemini.

Disasters: Cancer.

TAURUS *21 April – 20 May*

Gentle, affectionate and conservative, Taureans love their homes and families above all else. They are not terribly ambitious and their cautious natures thrive under routine. They can be snobbish and are great social climbers but are poor judges of character. They are masters of self-restraint, but underlying that placid facade is an extremely sensuous nature, that often finds release in a tendency for laziness and a love of good food. Relationships are a priority for Taureans, and they fall in love easily and passionately. If love goes wrong, they will often persevere, and remain in loveless marriages.

Perfect partner: Cancer.

Disasters: Scorpio.

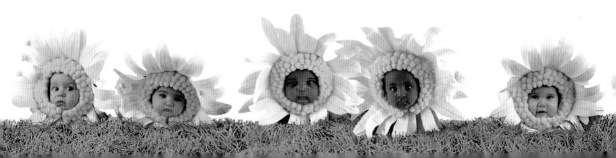

STAR SIGNS

GEMINI *21 May – 21 June*

The proverbial split personality, Geminis treasure clarity and reason. Often highly strung, Geminis are always overloaded with countless projects, none of which they explore in any depth. Their ready wit and lively minds make them popular, but often they are lacking in the long-term commitment that's necessary to make lasting friendships. Don't expect them to keep a secret – they love gossip and are always ready for a discussion as long as it's not about their emotions. They can be moody and emotionally immature. They need some freedom to be happily married and partners should be prepared for them to indulge in a few dalliances.

Perfect partner: Libra.

Disasters: Virgo.

CANCER *22 June – 22 July*

Caring, considerate and committed, Cancers seem made for the institution of marriage. They love their homes and are often great hoarders. Underneath their tough shells they are highly sensitive emotionally, and can easily feel rejected. They grow stronger when faced with adversity. They are often very sensual, but they try to hide their feelings from all but a privileged few. They are tenacious, and can be calculating. Don't expect them to spill the beans the first time you meet them – they'll hold themselves in check till they're sure you're worth the commitment, then attach themselves to you with Superglue! They are incredibly loyal and loving partners, even when the going gets tough.

Perfect partners: Taurus, Leo.

Disasters: Sagittarius, Aquarius.

STAR SIGNS

LEO *23 July – 22 August*

Warm, creative and generous, Leos demand the lion's share of attention. They crave constant approval and have a strong urge for self-expression – many end up in the theater and those who don't still act as if they are stars. They need to achieve their goals to be happy, and if thwarted or angered can be deadly. Some Leos are overconfident and vain, but equally many are truly charismatic. Leos are moody and veer to extremes. If they don't acquire some self-knowledge they can be strident egotists. They plunge into love affairs, and usually have plenty of admirers if they learn not to be too overbearing.

Perfect partners: Gemini, Cancer.

Disasters: Capricorn.

VIRGO 23 *August – 22 September*

Thoughtful, meticulous and critical, Virgos seem to have invented the word perfectionist. With their eye for detail and conscientious natures, they will accept only the highest of standards in everything. Because of this they have a tendency to be workaholics and are motivated by a strong sense of duty. They love gossip and their sharp wit can be malicious. Because of their tendency to rationalize, they often find relationships difficult, and will analyze everything to the 'enth' degree. They usually marry late, and often never walk down the aisle, but once committed make dependable, caring and considerate companions.

Perfect partners: Cancer, Taurus.

Disasters: Sagittarius.

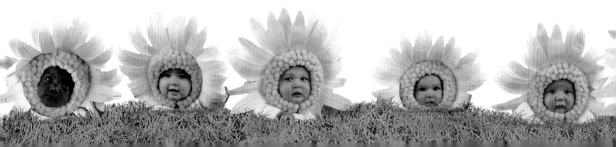

LIBRA *23 September – 22 October*

Charming, graceful, fair-minded Librans often top the popularity polls, and they make a special effort to present a smiling face to the world. They are diplomatic, and will go out of their way to avoid arguments in their constant search for harmony in all things. This can make them seem a little bland or two-faced at times, but they are only trying to please everyone all the time. They suppress anger, and this often leads to stress-related illnesses. They love things of beauty and will make an extra effort to get the means to afford an elegant lifestyle. Having a partner is an essential for Librans, and although they are very accommodating they like to feel they are in control emotionally.

Perfect partners: Librans will make a go of any relationship but Sagittarius is an especially good combination.

SCORPIO *23 October – 22 November*

Strong, resourceful Scorpios are personalities of extremes. They are able to endure physical and emotional hardships and their behaviour can fluctuate from spiritual to debauched. Their intense natures thrive on crises, which give them the opportunity to let off steam, and they are often their own worst enemies. They make devoted and committed friends but, if they scent betrayal, beware – they make relentless foes. They can be moody, but thrive in a loving, secure environment. They are known for their strong sexual energy but cherish a relationship that is equally as stimulating mentally and spiritually.

Perfect partners: Cancer, Libra.

Disasters: Aries, Gemini, Scorpio.

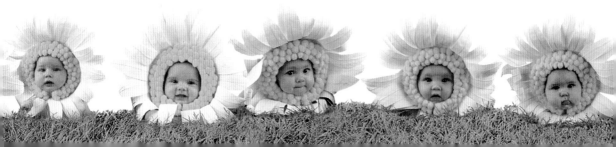

STAR SIGNS

SAGITTARIUS *23 November – 23 December*

Friendly, open, generous and vibrant, Sagittarians can be guaranteed to liven up any occasion. If they offend you with their frank remarks, remember that they are rarely malicious, and that they suffer from speak–first–and–think–later syndrome. They are always travelling in a bid to ease those ever–itchy feet. They love to mix with the "in" crowd and can be rather snobbish. They hate any restraint on their ebullient spirits and though they'll run through lovers at a rate of knots, they'll be very reticent about tying themselves to any one person.

Perfect partners: Virgo, Libra.

Disasters: Cancer, Scorpio.

CAPRICORN *23 December – 20 January*

Determined, practical and reliable, Capricorns will reach the positions of power and authority they crave no matter what. Their ambitions can lead them to be opportunistic and domineering, but underneath their stern facades they are often just great big softies. Although they seem reserved, if they're surrounded by friends you could be surprised by how decadent and outgoing they are. They are natural leaders and hate being subservient, though given power they can be tyrannical. They are artistic and frequently become involved in some sort of spiritual quest. They make loyal, faithful companions, although they're often a little emotionally insensitive.

Perfect partners: Virgo, Taurus.

Disasters: Gemini.

BIRTHSTONES

JANUARY *Garnet* – Constancy and truth
FEBRUARY *Amethyst* – Sincerity, humility
MARCH *Aquamarine* – Courage and energy
APRIL *Diamond* – Innocence, success
MAY *Emerald* – Tranquillity
JUNE *Pearl* – Precious, pristine
JULY *Ruby* – Freedom from care, chastity
AUGUST *Moonstone* – Joy
SEPTEMBER *Sapphire* – Hope, chastity
OCTOBER *Opal* – Reflects every mood
NOVEMBER *Topaz* – Fidelity, loyalty
DECEMBER *Turquoise* – Love and success

FLOWERS

JANUARY *Snowdrop* – Pure and gentle
FEBRUARY *Carnation* – Bold and brave
MARCH *Violet* – Modest
APRIL *Lily* – Virtuous
MAY *Hawthorn* – Bright and hopeful
JUNE *Rose* – Beautiful
JULY *Daisy* – Wide-eyed and innocent
AUGUST *Poppy* – Peaceful
SEPTEMBER *Morning Glory* – Easily contented
OCTOBER *Cosmos* – Ambitious
NOVEMBER *Chrysanthemum* – Sassy and cheerful
DECEMBER *Holly* – Full of foresight

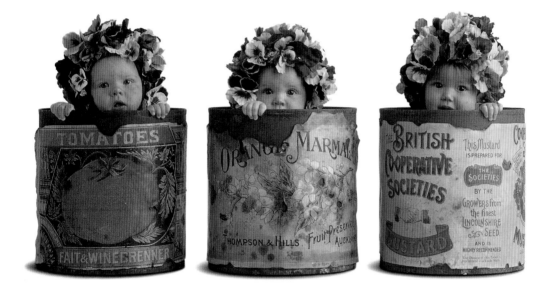

NOTES

NOTES